CUTE
HAND LETTERING
FOR JOURNALS, PLANNERS, AND MORE

CUTE
HAND LETTERING
FOR JOURNALS, PLANNERS, AND MORE

Cindy Guentert-Baldo

THUNDER BAY
P · R · E · S · S
San Diego, California

Thunder Bay Press
An imprint of Printers Row Publishing Group
A division of Readerlink Distribution Services, LLC
10350 Barnes Canyon Road, Suite 100
San Diego, CA 92121
www.thunderbaybooks.com
mail@thunderbaybooks.com

For Thunder Bay Press
Publisher: Peter Norton • Associate Publisher: Ana Parker
Senior Developmental Editor: April Graham Farr
Editor: Traci Douglas
Product Manager: Kathryn C. Dalby

Conceived, edited, and designed by Quarto Publishing plc
an imprint of the Quarto Group
The Old Brewery
6 Blundell Street
London N7 9BH
www.quartoknows.com

Quar: 325422

For Quarto
Editor: Claire Waite Brown
Art Director: Gemma Wilson
Designer: Karin Skånberg
Editorial Assistant: Charlene Fernandes
Publisher: Samantha Warrington

ISBN: 978-1-64517-149-2

Printed and bound in China

24 23 22 21 20 3 4 5 6 7

MIX
Paper from
responsible sources
FSC® C016973
www.fsc.org

Contents

MEET CINDY 6
ABOUT THIS BOOK 8

Chapter 1
JUST START 12
WHAT IS LETTERING? 14
DAILY PRACTICE 16
PENS 18
OTHER TOOLS AND MATERIALS 20
LETTERING JARGON 22
TAKE YOUR HANDWRITING TEMPERATURE 24
USE THE PRACTICE PAGES 26

Chapter 2
YOUR HANDWRITING 28
BASIC PRINTING 30
BASIC CURSIVE STROKES 36
BUILDING CURSIVE LETTERS 38
CONNECTING LETTERS 44
SMALL CHANGES, BIG IMPACT 50
BRINGING IT ALL TOGETHER 54

Chapter 3
SUPER SIMPLE LETTERING 56
. .
MAKE IT BULKY 58
EASY ROMANTIC PRINTING 64
SANS SERIF 70
ADDING SERIFS 76
FAUX-LLIGRAPHY 82
FUN FILL-INS 90
ADD SOME FLAIR 96
NUMBERS AND SYMBOLS 102

Chapter 4
THE NEXT LEVEL 108
. .
BLOCKING IT OUT 110
BUBBLE LETTERS 122
OVERLAPPING BUBBLE LETTERS 138
BOUNCY PRINTING 146
BOUNCY CURSIVE 152
NUMBERS AND SYMBOLS 158

Chapter 5
LET'S ADVANCE 162
. .
ADDING FLOURISHES 164
DECORATING LETTERS 174
SPACING 184
PATH TO A GREAT LAYOUT 188

Chapter 6
LETTERING IN JOURNALS 192
. .
PAIRING LETTER STYLES 194
HEADERS 200
BANNERS 208
FILLING IN THE SPACE 214
WORKING SMALL 218
IDEAS FOR YOUR JOURNALS 224
LETTERING CHEAT SHEET 228

Chapter 7
WHAT DO I DO NEXT? 232
. .
MOVING FORWARD 234
TAKE YOUR HANDWRITING TEMPERATURE 236

INDEX 238
ACKNOWLEDGMENTS 240

Meet Cindy

I've been making art and hand lettering for most of my life. It's been a hobby for as long as I can remember, and I started doing it professionally nearly 15 years ago. For many years I worked in a grocery store creating shelf signs and big display artwork, but in 2016 I started working for myself.

I've also used paper planners for as long as I can remember. Even before I started living the decorative-planner life, I would use different colored pens to take notes and generally make my daily plans bright and cheerful. There is nothing like a rainbow of colors to make a boring day of laundry look fun!

In 2013 I discovered the online planner community and the world of planner stickers. At the time I was having a lot of trouble making creative time for myself at home, since I had two small children and spent almost all of my creative energy at work each day drawing avocados with smiley faces and hand lettering the word "organic." It was difficult to justify spending any time making creative work just for me, even if I so desperately needed that time for myself.

Finding the planner community changed all of that. I was able to be productive *and* creative at the same time! And because I had so much fun decorating my planner, it encouraged me to *use* my planner every day, which made my life run more smoothly. At the time, there weren't a lot of people posting pictures of hand lettering in their planners on social media, so when I started showing what I did, people began asking me to teach them how to do it. That's when I started my YouTube channel.

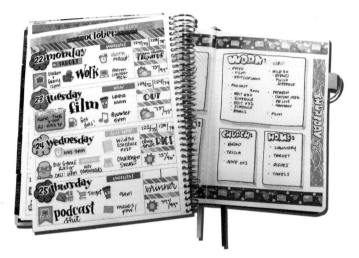

Now, almost 800 videos later, I've taught cute, fun hand lettering all over the USA. Most importantly, I'm surrounded by a community of people who are trying to fit creativity into their lives however they can, while maintaining a sense of humor along the way. The lettering is how we found each other, but the friendships are why we stay.

I'd love it if you joined us! **Cindy**

About This Book

As you work through this book you will learn a range of lettering styles. Work through the easy-to-follow instructions and try out what you learn on the practice pages. You'll soon be hand lettering like a pro.

CHAPTER 1: JUST START

Many beginners to lettering, especially in the planner and journaling communities, feel that they will never be as good as the people they see on social media. This chapter is here to assure you that great hand lettering is not as unattainable as you might think. It will introduce you to materials, basic lettering terminology, and the importance of practice.

PAGES
12-27

Other Tools and Materials

All you need is a practice pen (and pencil) and this book to learn the early techniques I'll be teaching. As you progress into more advanced lettering (like bubble letters), a few more tools will come in handy. I probably don't need to twist your arm to get you to buy more stationery supplies!

PENCILS
You will use pencils for sketching and the guidelines for some of the more complicated lettering styles. Pencils can be hard or soft, and everything in between. They are scaled from H (hard) to B (soft), or their "blackness." I generally use a 2B or 4B for lettering. I find these erase the best. Too soft a pencil will leave marks behind, while too hard will leave an indentation in the paper.

RULER
A regular unmarked straight edge can be great for keeping lines straight, but when you want to measure for spacing or layout, a ruler is a necessary addition to your toolkit.

ERASERS
A rubber or plastic eraser works well for removing sketching lines and guidelines.

PRACTICE PAPER
The practice pages in this book are perfect for initial practice, but I recommend you keep a notebook or a binder to practice even more! My favorite practice paper is graph or dot grid, as inexpensive as I can find. The goal is to practice a lot, so quantity matters over quality.

PAPER/PENS FOR FINISHED PIECES
When you want to create pieces of lettering art that will last a long time, you need to pay attention to the quality of your paper and pens. The terms you want to look for are "acid-free" and "archival quality." Acid-free paper will be most resistant to damage over time, and archival quality ink will be resistant to fading.

LIGHTBOXES/LIGHT TABLES
These are surfaces that are lit from underneath or within. You can place a draft of work on top, and then over that place a fresh piece of paper. This allows you to trace from your draft to a clean piece of paper for a finished piece. While not necessary, these can come in handy. You can purchase one for a variety of prices online or in craft stores. Alternatively, you can DIY one using a window or a piece of glass and a lamp, or use all sorts of other creative solutions.

REMEMBER ALL OF THESE TOOLS ARE GREAT, BUT NONE OF THEM WILL BE MUCH USE WITHOUT PRACTICING DAILY!

I SHARE MY KNOWLEDGE WITH YOU SO YOU CAN QUICKLY GET STARTED.

I'LL GIVE YOU TIPS AND ENCOURAGEMENT THE WHOLE WAY.

CHAPTER 2: YOUR HANDWRITING

This chapter considers ways to improve and change your handwriting through practice, with a review of basic printing and cursive. It also gives ideas, examples, and practice pages for making small changes that transform regular writing to hand lettering. Take your handwriting "temperature" to help you judge your progress through the book.

PAGES
28-55

I'LL GIVE ADVICE AS YOU EXPLORE YOUR OWN HANDWRITING.

FOLLOW THE STEPS THAT BREAK DOWN THE TECHNIQUES.

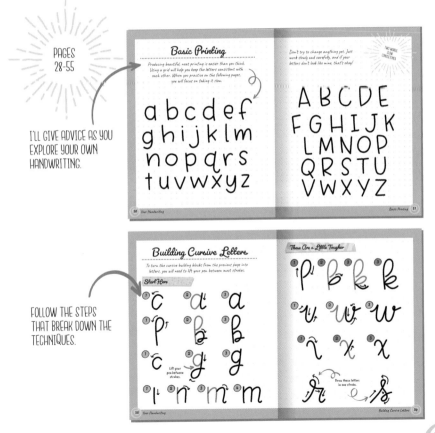

CHAPTERS 3–5: LETTERING STYLES PAGES

Starting with easy-to-learn lettering styles and moving gradually to more advanced techniques, Chapters 3 through 5 build on each other to provide a toolbox of journal lettering ideas and a sense of confidence. There are sections on spacing your letters and words, and the basics of laying out your lettering to achieve the desired result.

PRACTICAL ADVICE AND CLEAR ILLUSTRATIONS AND INSTRUCTIONS ARE ALL YOU NEED TO START LETTERING.

PAGES 56-191

THERE IS PLENTY OF PRACTICE SPACE WITH PROMPTS TO INSPIRE DAILY DRILLS AND EXPERIMENTATION.

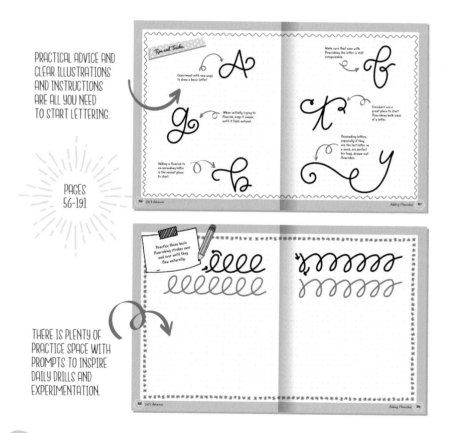

Cute Hand Lettering for Journals, Planners, and More

CHAPTER 6: LETTERING IN JOURNALS

This chapter takes everything you've learned so far and applies it to use in a journal or planner. There are tips on how to choose lettering, how to pair up different styles, and lists of ideas for potential uses in a journal context. There are also examples of banner doodles and other embellishments to pair with your lettering to be both decorative and functional.

PAGES
192-231

YOU COULD USE MY IDEAS FOR EMBELLISHMENTS AS A SPRINGBOARD TO CREATE YOUR OWN.

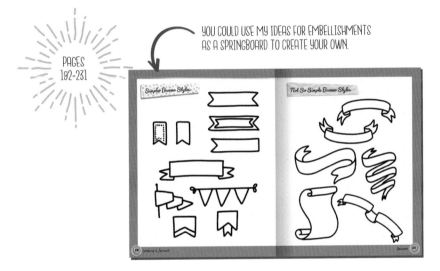

CHAPTER 7: WHAT DO I DO NEXT?

The final chapter gives encouragement and ideas on how to move forward in both lettering and journaling. You can also revisit your handwriting temperature to see the progress that has been made over the course of the book.

PAGES
232-237

CHAPTER 1

Just Start

No matter what the skill, everyone was a beginner once. Starting is often the hardest part. Luckily you've got me, and we'll start this hand-lettering journey together.

You'll discover what supplies to use and how important practicing is, and learn to approach this book with confidence, not fear!

What is Lettering?

Before we jump into learning new techniques and buying all the tools, let's take a moment to decipher the difference between handwriting and hand lettering.

HANDWRITING

This is the writing you do on a regular basis, from journaling to writing checks (yes, some people still do that!), to signing your name. Handwriting at its core can be both printing and cursive, or a mishmash of the two.

We are taught handwriting from a young age. It is a reflex for most of us, not requiring any thought. It is entirely possible to alter or change your handwriting, which we'll discuss in the next chapter.

Most importantly, your handwriting is unique to you. Much like your fingerprints, no one else has the exact same handwriting as you do, which is something to celebrate.

HAND LETTERING: THE ART OF DRAWING LETTERS

When you are learning hand lettering, you are essentially learning a drawing skill, not a writing skill. This is something I really want you to take to heart. The end result should still be recognizable as words (there are some hilarious examples on the Internet of hand lettering that reads as something entirely different than what was intended), but the method to get there is different.

I don't emphasize this to scare you, but instead, to set your expectations. As we work on the lettering styles in Chapter 3 and beyond, remember that you are learning to draw them, so approach those instructions in that way.

YOU CAN LEARN TO HAND LETTER. I BELIEVE IN YOU— YOU SHOULD BELIEVE IN YOU AS WELL.

Daily Practice

Practice, practice, practice is my hand-lettering mantra. I can't promise you will be a professional-level letterer after some time with this book, but I can promise you will not progress if you don't practice, even a little, every day.

Here are my tips for easy ways to help you get your daily practice.

TRUSTY COMPANIONS
Take a small notebook and pen with you everywhere. Practice a little when waiting in line, at the doctor's office, or anywhere else you spend idle during your day.

EPHEMERA EVERYWHERE
Practice your lettering in unexpected places, like your grocery list, on the back of junk mail, or on your bills— ideally, after you've paid them!

IMPORTANT PAGE!

PRACTICE.
PRACTICE.
PRACTICE.

PRACTICE PROMPTS
The practice pages in this book come with prompts. When you're struggling to come up with something to practice, go back to those pages and pick one.

GET OUT OF YOUR HEAD

You are only a few pages into this book and, let me guess. . . you've at least once thought something like:

Why bother trying? I'm going to be terrible at this.

Or perhaps,

I've already spent so much time trying to get better at lettering and I've failed. Why'd I waste my money on another book?

Or even,

My lettering/writing will never look as good as the stuff I see by other people on social media.

STOP IT!

There are two things I want you to do in order to get out of your own head (and your own way) when it comes to learning hand lettering.

1 Stop comparing yourself to everyone else out there. You have no idea how much time or practice they have put into their craft. The only person you should compare yourself to is yourself in the past, and the only person you should worry about impressing is yourself in the future.

2 Hang on to this book, keep a notebook for practicing, and do *not* throw your attempts away when you are learning. Later in this chapter, you will take a snapshot of your current handwriting. Save that. Save your practice pages. Save them so a few months from now, after you've been practicing, you can look back. Small changes aren't noticeable when they happen. It's easy to assume they aren't happening at all. But when you look back over time, you will see the progress. And you should celebrate it.

Pens

Yep, I'm devoting a whole section to pens. The pen you use will often have a big impact on how your handwriting and lettering looks. Here are some things to consider before selecting practice pens:

Sharpie marker

Pigma microns

Gel pens

Ballpoint pen

WHAT PENS WILL I NEED?

There are multiple brands, styles, and so on of pens that you could choose to practice with. At the very least, you need at least one good practice fine liner and one pen you'd be comfortable using in your planner. I prefer to practice with either a Sharpie marker or a Papermate Flair Fineliner.

TIP TYPE

There are several different types of pens you could be working with. Brush pens are used for modern calligraphy (we won't be doing that in this book, but I wanted to mention them). Other tip types include ballpoint, gel, and felt-tip, to name a few.

TIP SIZE

Pen tips can range from ultra-fine (think .005mm) to big and broad.

I prefer a medium to large tip for most lettering practice, because it helps camouflage any shakiness when you are beginning.

COLOR

I very rarely branch out into other colors, preferring to practice and letter with black ink. This doesn't mean you can't—as a matter of fact, including different colors can add variety even before you learn new lettering styles.

HOW HEAVY IS YOUR HAND?

In other words, how hard do you grip a pen and how hard do you press down? I am extremely heavy-handed, so am most comfortable lettering with a medium felt-tip pen. Trying different pens as you practice will help you to understand your own unique grip and decide which pen is most comfortable for you.

Other Tools and Materials

All you need is a practice pen (and pencil) and this book to learn the early techniques I'll be teaching. As you progress into more advanced lettering (like bubble letters), a few more tools will come in handy. I probably don't need to twist your arm to get you to buy more stationery supplies!

PENCILS

You will use pencils for sketching and the guidelines for some of the more complicated lettering styles. Pencils can be hard or soft, and everything in between. They are scaled from H (hard) to B (soft), or their "blackness." I generally use a 2B or 4B for lettering: I find these erase the best. Too soft a pencil will leave marks behind, while too hard will leave an indentation in the paper.

RULER

A regular unmarked straight edge can be great for keeping lines straight, but when you want to measure for spacing or layout, a ruler is a necessary addition to your toolkit.

ERASERS

A rubber or plastic eraser works well for removing sketching lines and guidelines.

PRACTICE PAPER

The practice pages in this book are perfect for initial practicing, but I recommend you keep a notebook or a binder to practice even more! My favorite practice paper is graph or dot grid, as inexpensive as I can find. The goal is to practice a *lot*, so quantity matters over quality.

PAPER/PENS FOR FINISHED PIECES

When you want to create pieces of lettering art that will last a long time, you need to pay attention to the quality of your paper and pen. The terms you want to look for are "acid-free" and "archival quality." Acid-free paper will be most resistant to damage over time, and archival quality ink will be resistant to fading.

LIGHTBOXES/LIGHT TABLES

These are surfaces that are lit from underneath or within. You can place a draft of work on top, and then over that place a fresh piece of paper. This allows you to trace from your draft to a clean piece of paper for a finished piece. While not necessary, these can come in handy. You can purchase one for a variety of prices online or in craft stores. Alternatively, you can DIY one using a window or a piece of glass and a lamp, or use all sorts of other creative solutions.

REMEMBER. ALL OF THESE TOOLS ARE GREAT. BUT NONE OF THEM WILL BE MUCH USE WITHOUT PRACTICING DAILY.

Lettering Jargon

As you work through the book you'll come across some lettering jargon. These might be "official" lettering terms, or just how I refer to something. You may know these already, but if at any point you feel unsure, you can come back to these pages to feel reassured!

PRINT
Lettering or writing where the individual characters do not connect.

CURSIVE
Lettering or writing where the individual characters are typically (but not always!) connected.

UPPERCASE
The capital letters of an alphabet, often used for proper nouns or the start of a sentence.

LOWERCASE
The smaller letters of an alphabet, often used for the bulk of a word.

SERIF
The little bar or line generally at the top and bottom of a letter. (An example of a serif font is Times New Roman.)

SANS SERIF
A font or lettering style without the little serif bars. (An example of a sans-serif font is Helvetica.)

STROKE
The lines that make
up the letters.

UPSTROKE
When drawing a letter,
the strokes where your
pen travels upward on
the paper.

DOWNSTROKE
When drawing a letter,
the strokes where your
pen travels downward on
the paper.

ASCENDER
The part of a letter that
rises above the main body
of the letter.

DESCENDER
The part of a letter that
drops below the main
body of a letter.

CROSSBAR
The line that crosses a
vertical letter stroke, like
the crossing of a "t."

TAIL
The line exiting a letter,
mainly in cursive or script,
that leads you to your
next letter.

SKELETON
The guidelines used in
drawing more complicated
lettering, giving you a
pattern to trace around.

Take Your Handwriting Temperature

One of the most important things you can do to feel good about your progress is to see where you've come from. I recommend taking your "handwriting temperature" at least once every 30 days you practice. For this book, you'll do it here at the beginning and again at the end.

I am unique and I have a beautiful hand writing

What do you love about your handwriting? You must put something here, and it needs to be a real compliment.

What would you change about your handwriting? Be specific: for example, "I'd like to have rounder letters."

Write the entire alphabet, in uppercase and lowercase, in your
regular writing. Don't try to fancy it up; you want a snapshot
of your writing at this moment in time.

A B C D E F G H I J K L M N O
P Q R S T U V W X Y Z

a b c d e f g h i j k l m n o p q r s t u
v w x y z

Date ...11/16/21...

Use The Practice Pages

Every time you learn something new in this book, you'll find at least one, if not more, practice pages. Use them. Take what you've learned, apply it to the prompts provided, and fill those pages up.

The practice pages arc not there to fill up space; they are there to encourage you to take immediate action on each new style or technique.

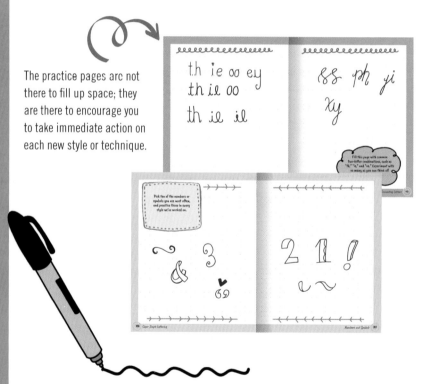

In case you haven't caught on yet, I consider practice to be the most important part of the hand-lettering process.

Use this page to make a promise to yourself to practice. Make a goal to practice a certain amount every day or week and write it here.

I promise myself:

I will not give up on anything

If, while working in this book, you feel like you don't want to try anymore, come back to this page to remind yourself of your promise.

YOU'VE GOT THIS!

CHAPTER 2

Your Handwriting

As with anything, before you can learn to hand letter you have to start with the basics. Luckily for you, you've likely been using *your* basics since you were young. . . your handwriting!

In this chapter you will look at your usual handwriting, both printing and cursive, and discover ways to play with those skills to begin hand lettering.

Basic Printing

Producing beautiful, neat printing is easier than you think. Using a grid will help you keep the letters consistent with each other. When you practice on the following pages, you will focus on taking it slow.

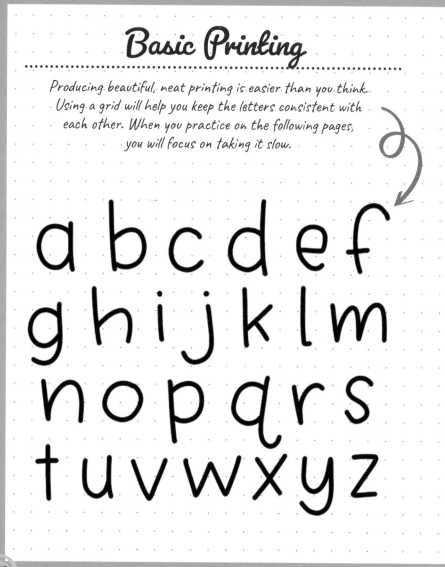

a b c d e f
g h i j k l m
n o p q r s
t u v w x y z

Don't try to change anything yet. Just work slowly and carefully, and if your letters don't look like mine, that's okay!

A B C D E

F G H I J K

L M N O P

Q R S T U

V W X Y Z

The first exercise is to print the alphabet, in both lowercase and uppercase, the way you usually would—speed, size, and all!

A B C

D E F G H I J K

L M N O P Q R

S T U V W X Y Z

a b c d e f g h i j k l m n
o p q r s t u v w x y
z

Write both alphabets again,
but this time go slow and focus on keeping
your letters consistently the same size as
each other, using the grid to guide you.
Do you notice any differences?

A B

C D E F G H

I J K L M N

O P Q R S T

U V W X Y Z

a b c d e f g h
i j k l m n o p q
r s t u v w x y z

Basic Cursive Strokes

You've made a start with printing; now let's look at cursive. All cursive letters are made from the same building blocks and strokes. Start by practicing just these strokes.

Try it yourself.

C C C PC

P P P P

PRACTICE THESE EVERY DAY AND THEY'LL START FEELING NATURAL BEFORE YOU KNOW IT!

You will see how these building blocks are used to make actual letters on the next page.

Building Cursive Letters

To turn the cursive building blocks from the previous page into letters, you will need to lift your pen between most strokes.

Start Here

① c ② d ③ a

① p ② b ③ b

① c ② g ③ g

Lift your pen between strokes.

① l ② n ③ m ④ m

① ② ③ ③

① ② ③

① ② ③

Draw these letters
in one stroke.

Follow my advice and guidelines but, remember, if
you've always written a letter a certain way, stick
with it. There's no need to reinvent the wheel!

a b c d e f

g h i j k l

m n o p q r

s t u v w

x y z

A B C
D E F G H
I J K L M
N O P Q R
S T U V W
X Y Z

Practice your cursive lettering by writing names. Need some inspiration? How about the people you love or celebrities you have a crush on?

Maggie

Michael

linda addy

jo Ella

Connecting Letters

Cursive letters are connected at their entrance and exit points.

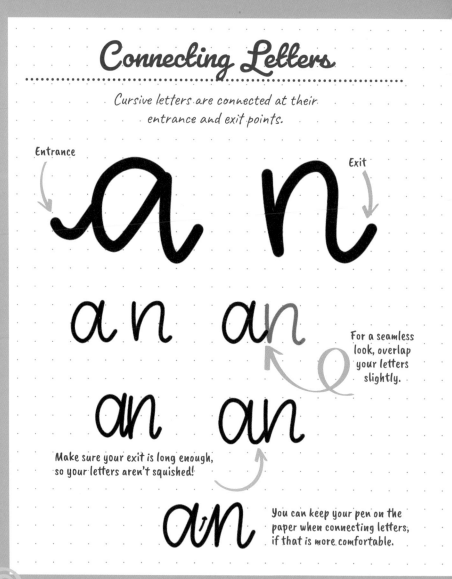

Entrance

Exit

a n

an an

For a seamless look, overlap your letters slightly.

an an

Make sure your exit is long enough, so your letters aren't squished!

an

You can keep your pen on the paper when connecting letters, if that is more comfortable.

o op oh

o or os

Lower your exit for
single-stroke letters,
like this "r."

ss ss

If you struggle to connect
two loopy "s" letters,
try this version instead.

abcdef

ghijkl

mnopq

rstuvw

xyz

THE MORE YOU
PRACTICE, THE
MORE YOU WILL GET
COMFORTABLE WITH
CONNECTING DIFFERENT
COMBINATIONS
OF LETTERS.

I prefer not to connect
uppercase letters, but
here are some examples
if you want to try!

Aa → *Aa*

Ph → *Ph*

Em → *Em*

re oo

th

ll

al

Fill this page with common
two-letter combinations, such as
"th," "ie," and "oo." Experiment with
as many as you can think of!

Small Changes, Big Impact

There are a number of ways to start to change your usual letter style. These are the kinds of techniques we will develop throughout the book.

Crossbar

Move the crossbar up or down on your letters.

A A A A B B B

E E E R R R

f f f h h h

Try both consistent and inconsistent sizing.

abc → abc

Start by changing one letter at a time.

a g → a g

Make your letters tall and narrow . . .

Aa Ee Mm

. . . or short and wide.

Aa Ee

april

march

july

december

Experiment with the
small changes you have
learned by writing out
the names of the months.

Bringing It All Together

Celebrate your progress by writing out the lyrics from a song you love using the techniques you liked best from this chapter. You rock!

Jingle Dells JINgle
All the way; Oh what
Fun It is to ride in a

CHAPTER 3

Super Simple Lettering

In this chapter you will take your handwriting to the next level by adding bulk, swirls, and everything in between to change your everyday printing and cursive into hand lettering.

Yes, it's that easy!

Make it Bulky

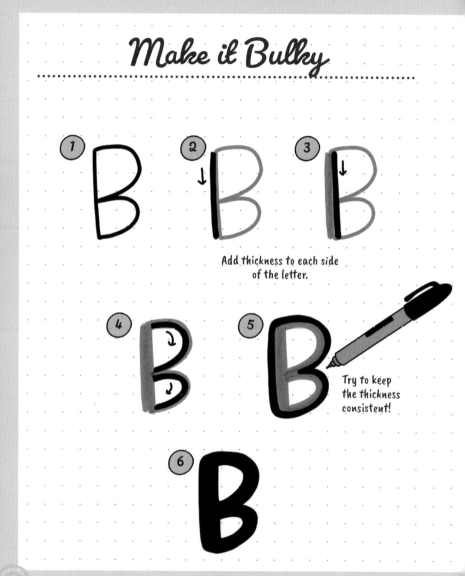

① B

② B
↓
Add thickness to each side of the letter.

③ B
↓

④ B

⑤ B
Try to keep the thickness consistent!

⑥ B

Less is more . . .

N

. . . or is more more?

N

REMEMBER: YOU
CAN ALWAYS ADD
MORE BULK, BUT
YOU CAN'T TAKE
IT AWAY!

Add a highlight.

R

A

Try making only one side thicker.

This bulky letter style is wonderful for emphasizing headers, dates, or anything you'd like to call special attention to!

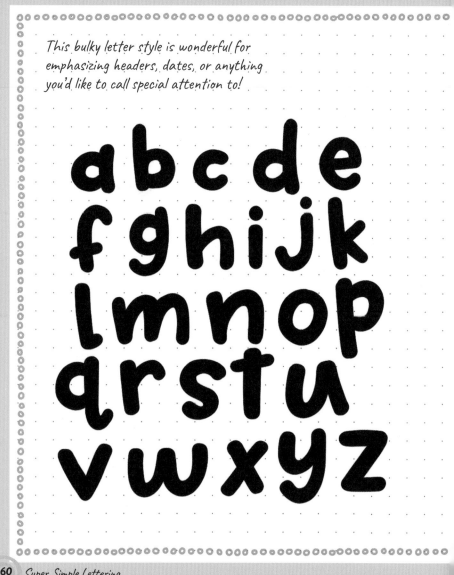

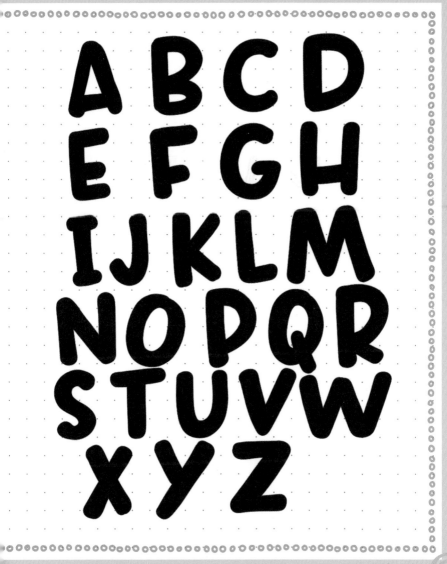

dog

Snow

r

Use your bulky letters to make a list of things you love about yourself—and you'd better fill these pages up!

Easy Romantic Printing

Draw over these strokes to get a feel for swirls:

ↄↄↄↄↄↄↄ

bbbbbbb

GGGGGGG

Add one swirl per letter . . .

A

. . . or more!

m

h

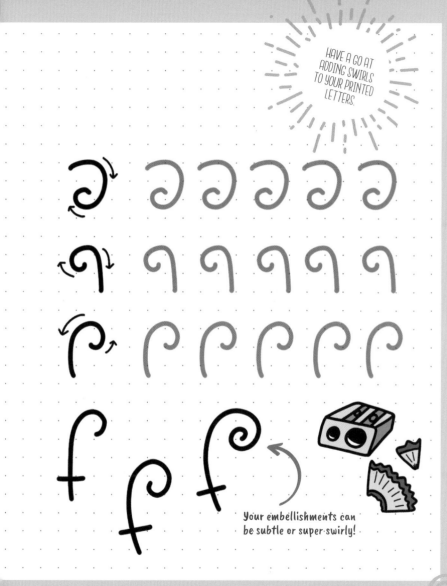

HAVE A GO AT ADDING SWIRLS TO YOUR PRINTED LETTERS.

Your embellishments can be subtle or super-swirly!

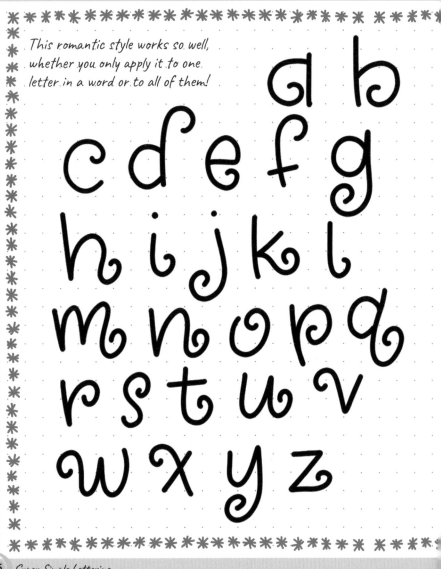

This romantic style works so well, whether you only apply it to one letter in a word or to all of them!

a b c d e f g h i j k l m n o p q r s t u v w x y z

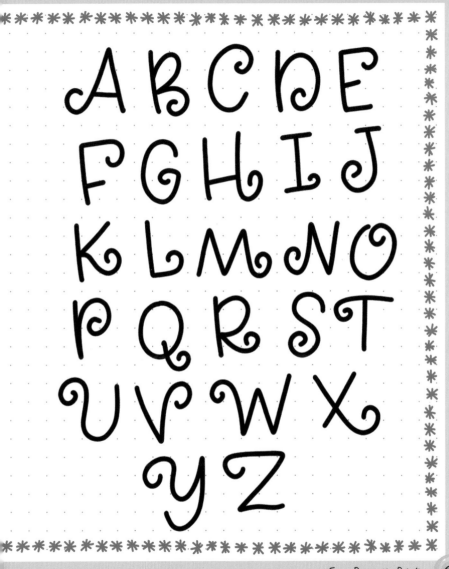

Super Simple Lettering

Use different styles of romantic printing to letter the names of types of shapes.

Sans Serif

1 2 3

A A A

1 2 3

C C C

Keep the added
thickness
consistent for
all letters.

1 2 3

R R R

① ②

③ ④

Some letters will have two thickened sides.

① ② ③ ④

"S" takes lots of practice, so don't give up!

Combine the sans-serif technique with your own handwriting. Remember, consistency is key!

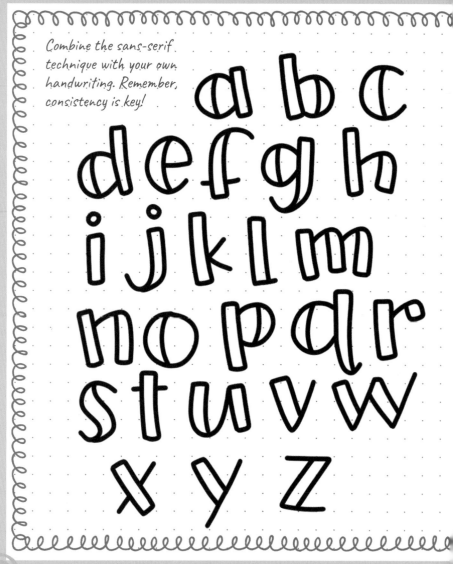

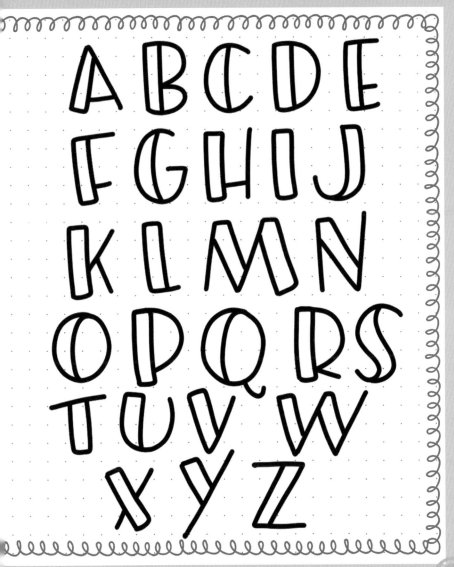

Happy? Excited?
Letter as many
different moods
as you can think
of in the sans-
serif style.

Happy

Energetic

Adding Serifs

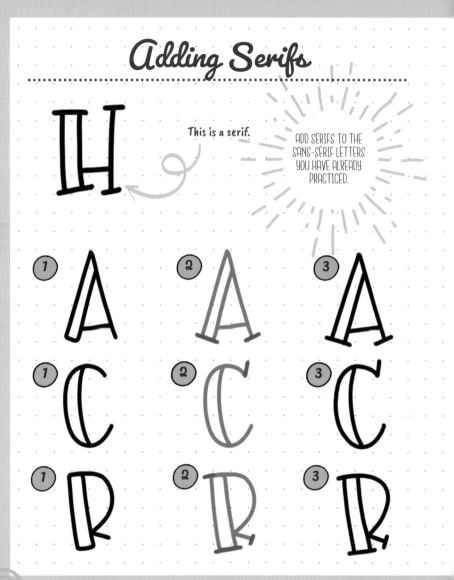

This is a serif.

ADD SERIFS TO THE SANS-SERIF LETTERS YOU HAVE ALREADY PRACTICED.

1 A
2 A
3 A

1 C
2 C
3 C

1 R
2 R
3 R

Add your serifs to the top of
letters if you like the look!

M M

l L

This works
for "E" as well!

y y

You can even try
a swirly serif.

b d

Lowercase serifs
should point away
from the letter.

Experiment with adding more
or fewer serifs to your letters.

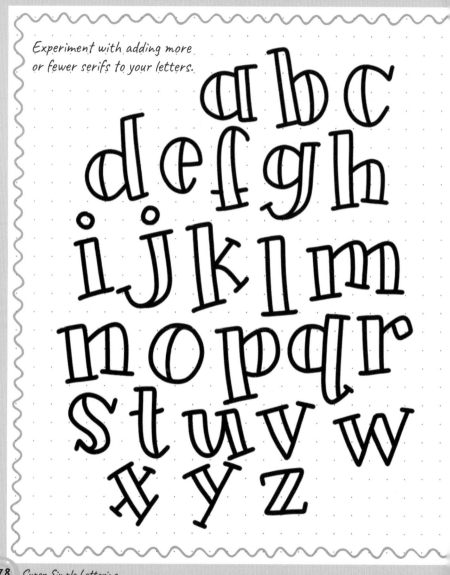

abc
defgh
ijklm
nopqr
stuvw
xyz

ABCDE
FGHIJ
KLMN
OPQRST
UVWX
YZ

Use your serif letters to write out the
names of colors. For extra fun, fill in the
space in each letter with those colors!

RED

Pink

Faux-lligraphy

Downstroke

Upstroke

FAUX-LLIGRAPHY IS ALL ABOUT THE DOWNSTROKES.

1

2

3

For the faux-lligraphy letter style add thickness to the downstrokes.

In most cases, add the thickness on the right side of the downstroke.

For "h," "m," and "n" move the thickness to the left side of the curved downstrokes.

Spread your cursive out a little to create space for the thickened downstrokes.

(1) m (2) m (3) **m** Like this...

(1) m (2) m (3) **m** ...not that.

Keep the thicknesses consistent with each other.

u **u** ...yep!

Nope...

If the edges of the thick
strokes look a bit harsh...

(1)

(2)

...start the thickened
downstroke a little along
the original line, and
curve the thickness
out from there.

(3)

(1)

(2)

Erase the
overlapping line...

...if you don't want to
fill in the thickness.

(3)

Use the faux-lligraphy letter style to fake the look of brush lettering. I won't tell if you don't!

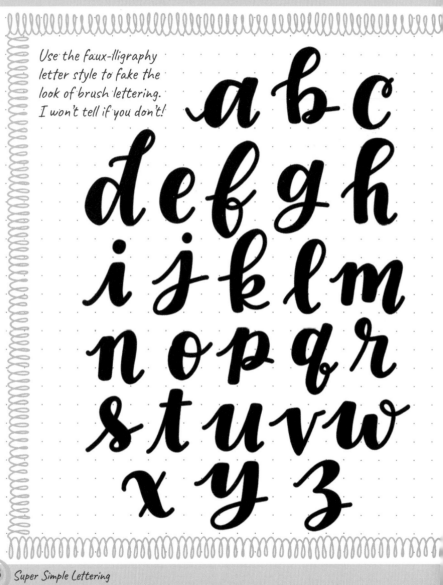

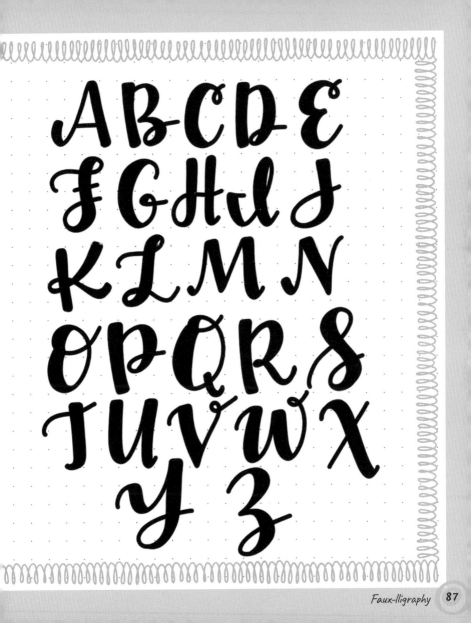

Think of a few short sayings (four to five words) and letter them here in the faux-lligraphy style.

n

Fun Fill-ins

Stripes

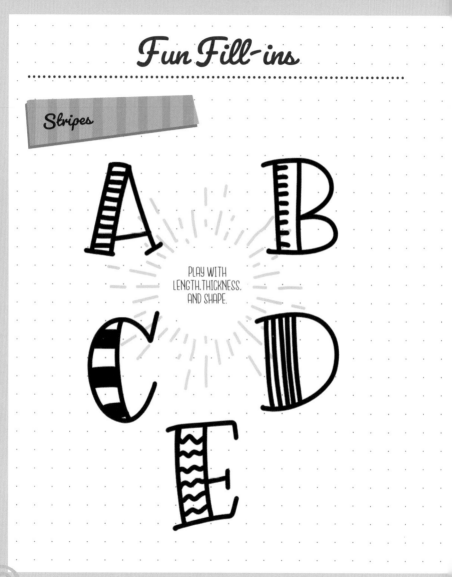

PLAY WITH LENGTH, THICKNESS, AND SHAPE.

Use different
amounts and
placements of
solid fill-ins.

You can even
play with color!

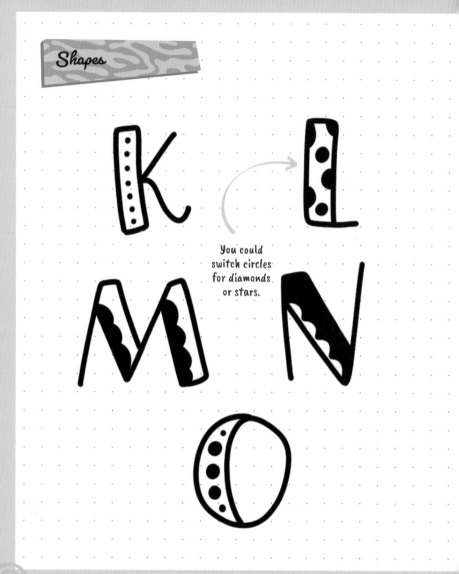

You could switch circles for diamonds or stars.

Highlights can be created with negative space or with white gel pens.

Experiment here with the different fill-in techniques. Try a selection of stripes, solids, shapes, and highlights to find which ones you like best.

A b C d

e F G h

I j K L

mNOP
QrSt
uVW
XYZ

Add Some Flair

Small changes to individual letters, whether printing or cursive, can add some fun and personality to your lettering.

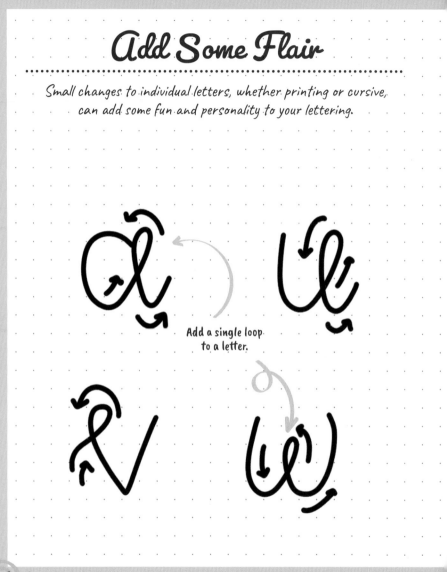

Add a single loop to a letter.

You can add flair
to lowercase or
uppercase letters
... or both!

LESS IS MORE!

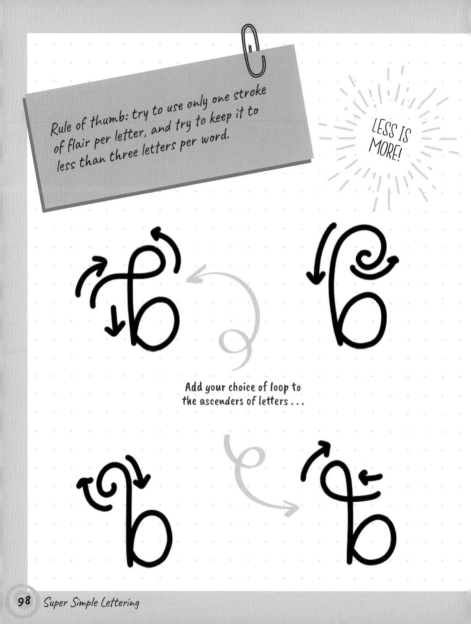

Add your choice of loop to
the ascenders of letters . . .

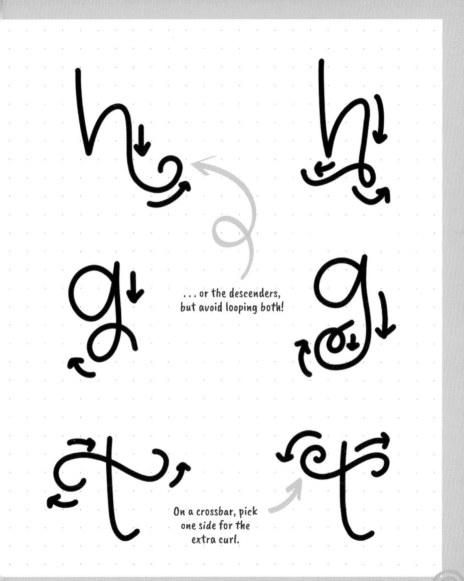

... or the descenders, but avoid looping both!

On a crossbar, pick one side for the extra curl.

Show your flair by adding it to a list of several of your favorite things! As you make the list, experiment by adding flair to different letters, and in varying quantities.

Puppy

Numbers and Symbols

Here are various examples of numbers written using some of the styles we've worked with in this chapter. Adapt them to your own personal style for some extra flavor.

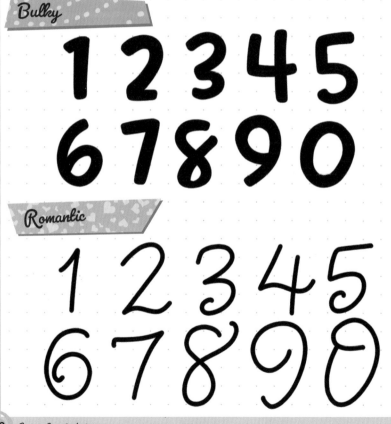

Bulky

1 2 3 4 5
6 7 8 9 0

Romantic

1 2 3 4 5
6 7 8 9 0

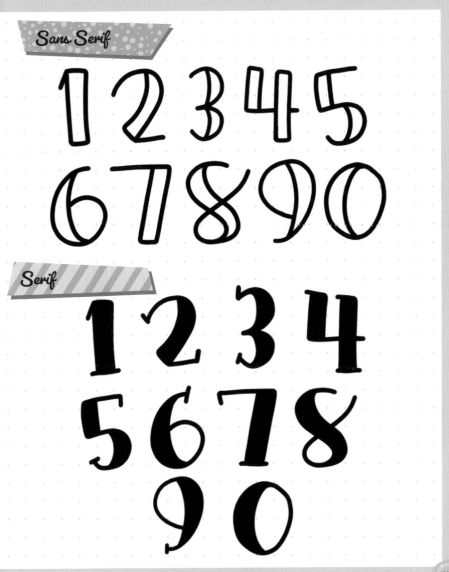

Here are various punctuation marks and accents written using some of the styles we've worked with in this chapter.

Bulky

/ & ? ! : ; –

´ ` ^ ∨ ° ·· ˘ ~

ç ø ß Æ

Romantic

/ & ? ! : ; –

´ ` ^ ∨ ° ·· ˘ ~

ç ø ß Æ

/ & ? ! : ; —

´ ` ^ ˇ ˚ .. ˘ ~

Ç Ø Œ Æ

Serif

/ & ? ! : ; —

´ ` ^ ˚ .. ˘ ~

Ç Ø Œ Æ

Pick ten of the numbers or symbols you use most often, and practice those in every style we've worked on.

CHAPTER 4

The Next Level

It's time to level up and try some more
complicated lettering styles! From puffy to
bouncy, we will be working on adding all sorts
of fun elements to your hand-lettering toolkit.
Don't rush through these next pages—each
time you practice you'll be building new
muscle memory. With a little time you'll be
a bubble-lettering master!

Blocking It Out

Block lettering is great in its own right, but also forms the basis for the bubble lettering that you will learn about next.

YOU CAN CREATE A BLOCK LETTER FROM ANY REGULAR LETTER.

You can block out sans-serif, serif, or even cursive styles.

1

2

3

Draw your initial letter skeleton a little larger and more open, so you have room to draw around it.

4

5

6

7

When you trace around the outside with pen, keep the corners sharp.

1

2

The guidelines
you start with
should all
be the same
length.

3

4

5

To keep your
angles correct,
overlap your initial
rectangles. You'll
fix this when you
trace around the
letter at the end.

6

7

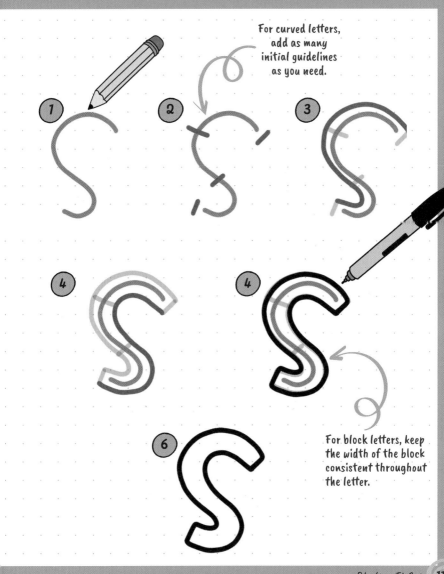

For curved letters, add as many initial guidelines as you need.

For block letters, keep the width of the block consistent throughout the letter.

We all have lettering styles we struggle with. Mine is block lowercase letters. But if I can do it, I know you can as well.

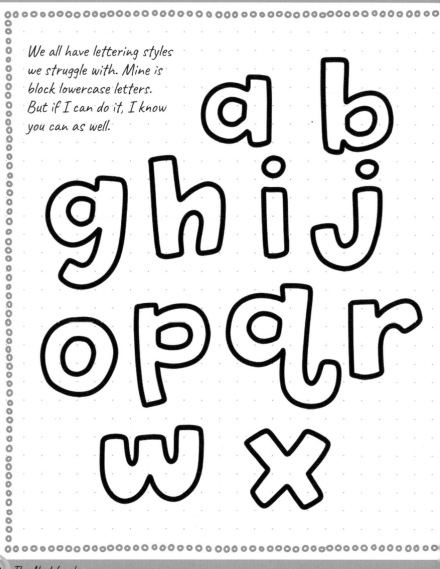

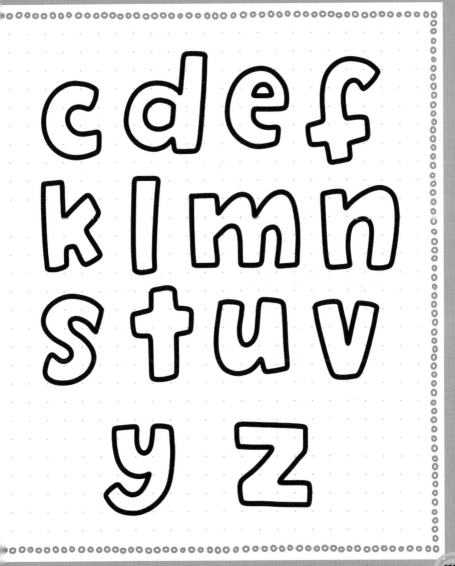

Remember that block lettering is drawing around the outside of the letter, not drawing the letter the way you are used to. You got this!

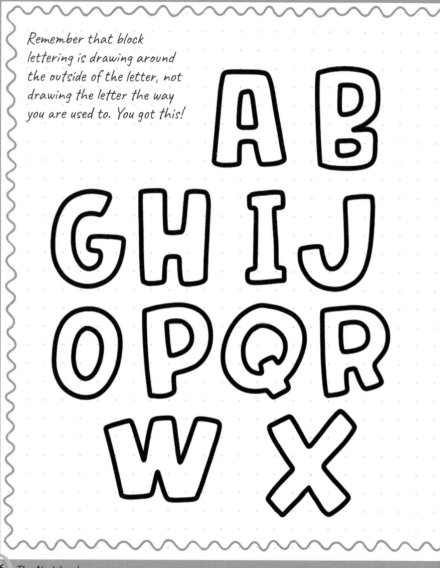

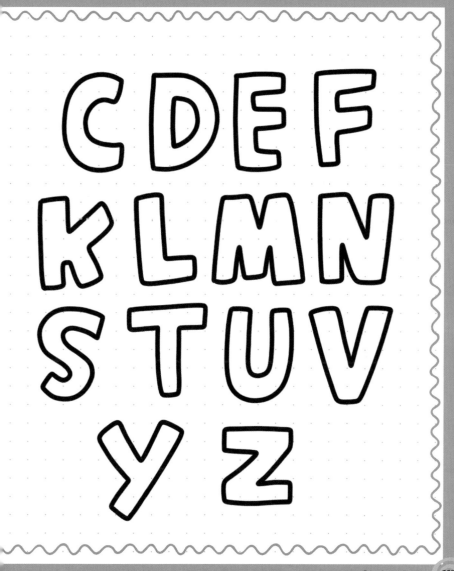

Trace around each of these letters to get the feel for block lettering. Remember to try to keep a consistent space between the letter skeleton and what you draw.

A B

G H I J

N O P Q

V W

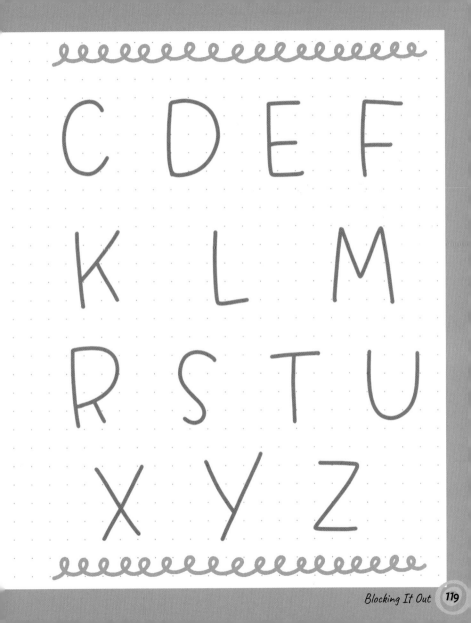

C D E F

K L M

R S T U

X Y Z

Try writing the names of different animals in block letters.

Bubble Letters

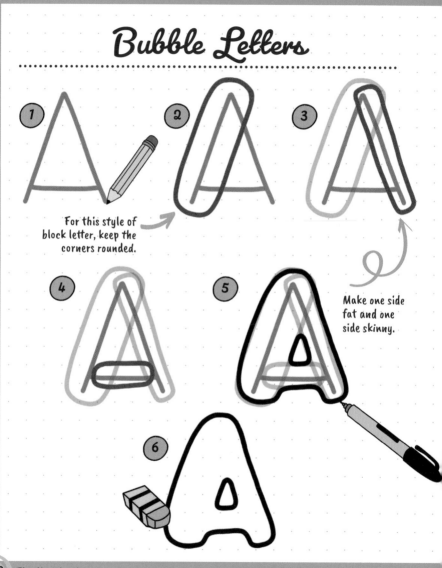

1 For this style of block letter, keep the corners rounded.

2

3 Make one side fat and one side skinny.

4

5

6

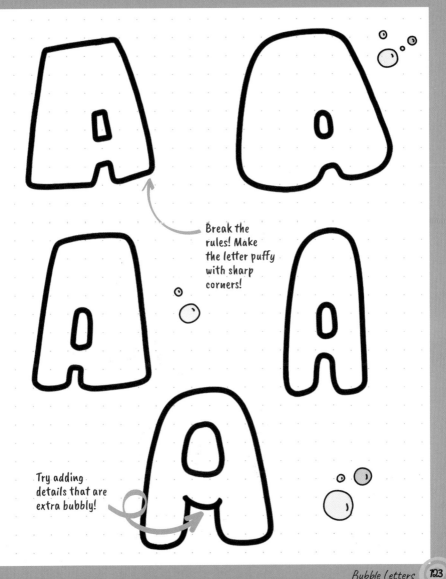

Break the rules! Make the letter puffy with sharp corners!

Try adding details that are extra bubbly!

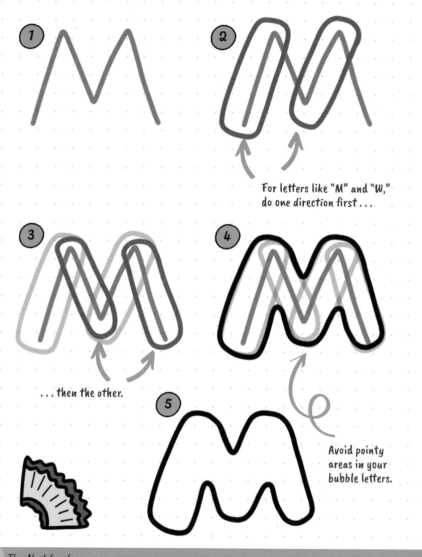

① ②

For letters like "M" and "W,"
do one direction first . . .

③ ④

. . . then the other.

⑤

Avoid pointy
areas in your
bubble letters.

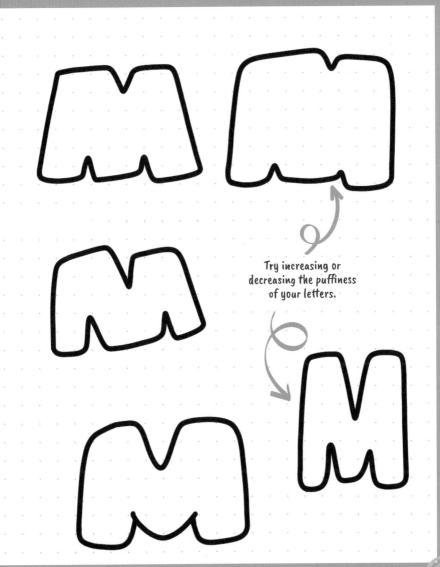

Try increasing or decreasing the puffiness of your letters.

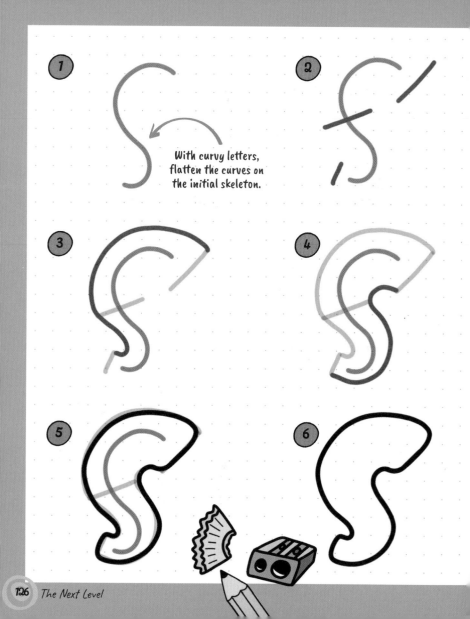

1

2

With curvy letters,
flatten the curves on
the initial skeleton.

3

4

5

6

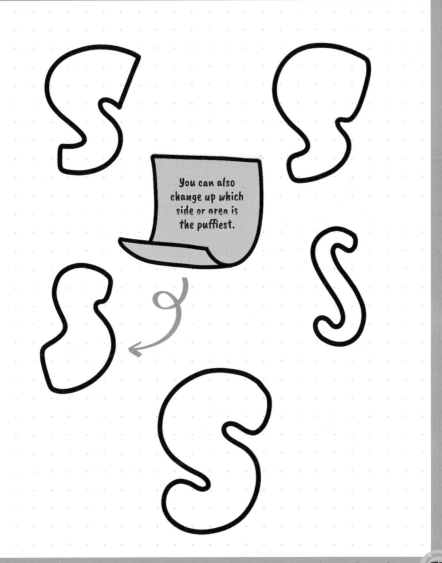

These letters are like block letters with rounded corners. Imagine filling each of them with air like a balloon animal—skinny, consistent balloons!

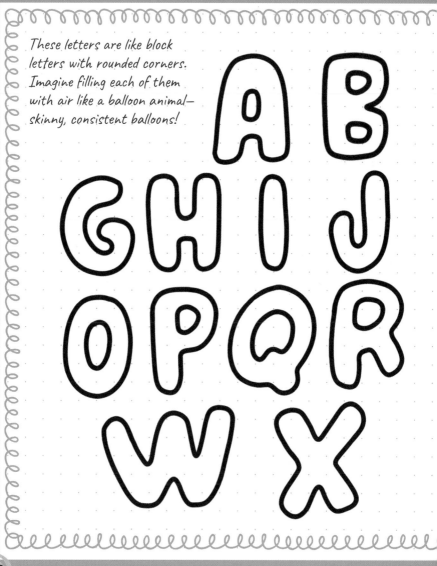

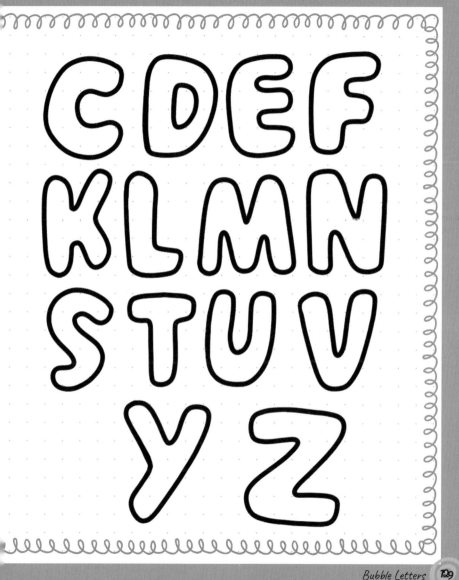

If the last alphabet featured skinny balloons, then these balloons are *full* of air. This is my absolute favorite style of lettering!

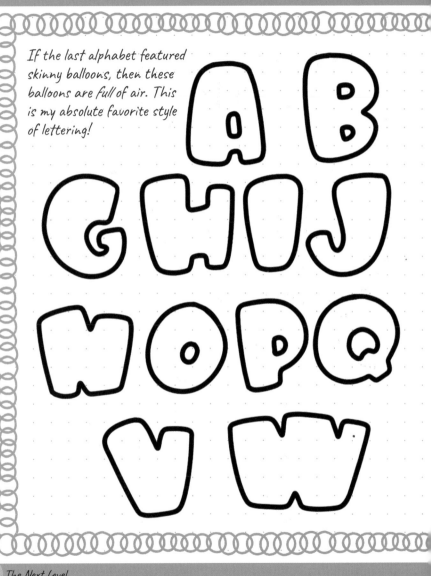

C D E F
K L M
R S T U
X Y Z

Pick a style of bubble lettering and practice it by tracing around each of these letter skeletons. Remember to round off the corners.

A B

G H

M N O P

U V W

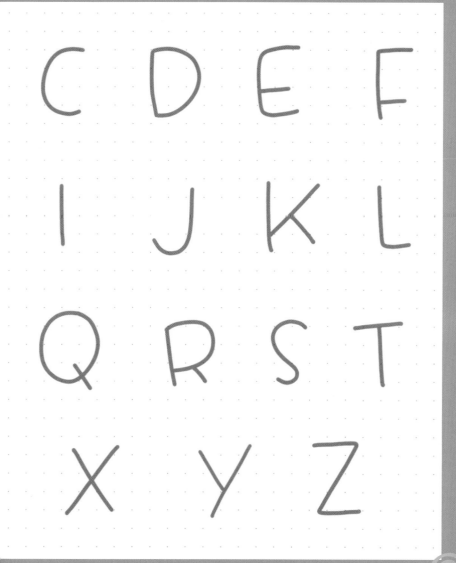

Send these balloons into the sky, and letter different bird names in your favorite bubble style.

Which days will you pamper yourself this week? Letter them with bubble letters. Hint: you should letter all seven days!

Overlapping Bubble Letters

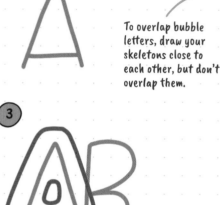

(1)

(2)

To overlap bubble letters, draw your skeletons close to each other, but don't overlap them.

(3)

(4)

(5)

(6)

Trace the letter you want in the front first, then trace the next letter, avoiding the overlapping lines.

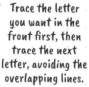

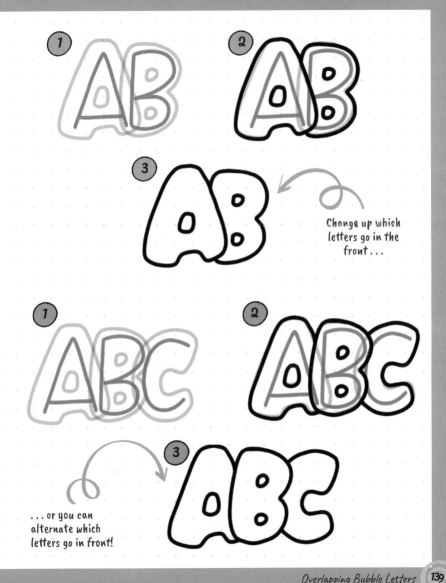

Change up which letters go in the front . . .

. . . or you can alternate which letters go in front!

My favorite way to overlap bubble letters is to have the leftmost letter in the front. This is the easiest way to learn to overlap.

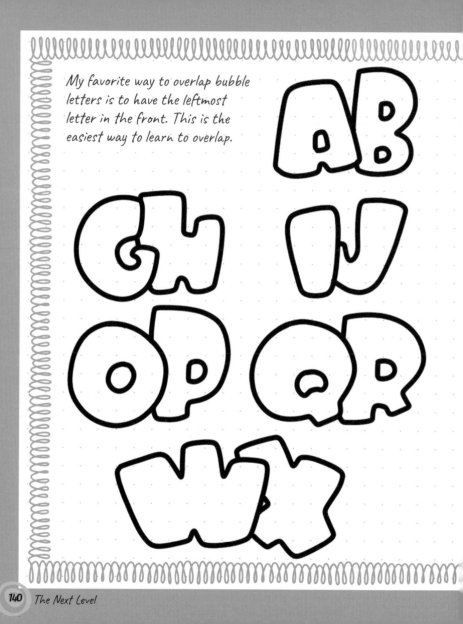

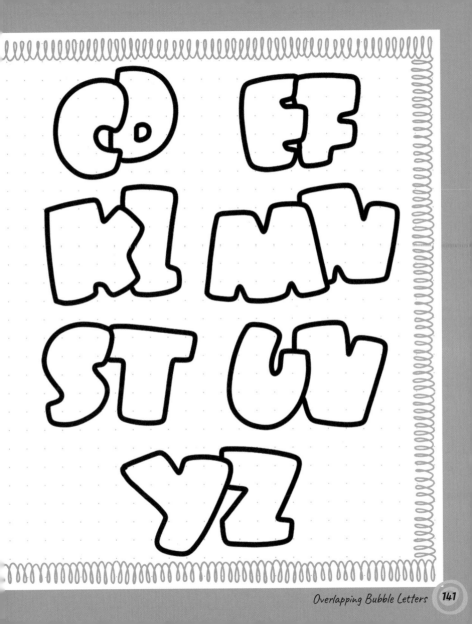

You might like putting the rightmost letter in the foreground of your overlapping—or you can alternate right and left!

AB

GH

IJ

OP

QR

KX

Blowing bubbles is one of my favorite summer activities. Letter the things you like to do in summer using overlapping bubble letters.

Bouncy Printing

a b c d e f

Your
baseline

The baseline
for the bounce

m n o p q

Have the bottom of the letter alternate between the main baseline and the bounce baseline.

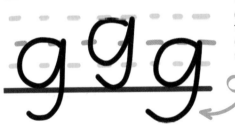

For letters with descending elements, the descender should always go below the relevant baseline.

When bouncing an ascending letter and a descending letter next to each other, play around until you find what you like.

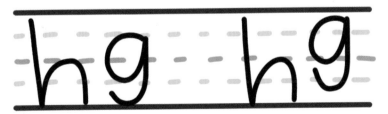

Use these guidelines to practice bouncing letter. You can use the *other* baselines to try bouncing in a more extreme way. The higher the bounce baseline, the more pronounced the effect will be!

Bounce some balls! Use the bounce printing style to letter the names of games played with balls. I won't judge you if you doodle some as well.

Bouncy Cursive

Now apply bouncing techniques to your cursive lettering.

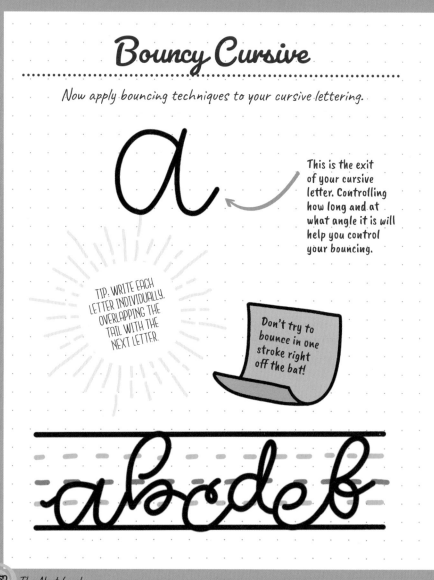

This is the exit of your cursive letter. Controlling how long and at what angle it is will help you control your bouncing.

TIP: WRITE EACH LETTER INDIVIDUALLY, OVERLAPPING THE TAIL WITH THE NEXT LETTER.

Don't try to bounce in one stroke right off the bat!

For a small bounce, bring your tail up and sit the next letter on the first bounce baseline . . .

a a a

. . . or down, so the next letter sits back on the main baseline.

a a a

For a bigger bounce, travel over two baselines.

a a a

a a a

For letters like "o," the direction of your tail matters when you decide to bounce up or down.

For letters like "e," keep the direction of your tail the same, but lengthen or shorten it.

For some letters you
have to do it all in one
stroke. If you find a
letter (like "r") that
gives you trouble,
practice it more often
to get the hang of it.

Letters that have
descenders don't
require more length,
just a change in the
angle of the tail.

It's practice time! Use these guidelines to help you get into the flow of bouncing your cursive. It may feel awkward for a while, but if you keep at it, it will start to feel more natural.

Numbers and Symbols

Here's how numbers and symbols look using block and bubble lettering.

Block

1 2 3 4 5
6 7 8 9 0

Bubble

1 2 3 4 5
6 7 8 9 0

/ & ? ! : ; —

/ \ ∧ ∨ ° ‥ ⌣ ~

Ş Ø Β Æ

/ & ? ! : ; —

/ \ ∨ ∧ ° ‥ ⌣ ~

Ş Ø Β Æ

1

3

5

Practice drawing numbers in both block and bubble styles. Use an inside skeleton as before to help you create them.

CHAPTER 5

Let's Advance

Now that you've tried out some different lettering styles, it's time to add those fancy bits and pieces! From decorating with little doodles to learning to flourish like a master, you'll soon be able to add your own personality to the lettering you've practiced.

We will also look at the basics of spacing and layout, to transform your individual letters into pieces of lettering art!

Adding Flourishes

On pages 96–101 you learned ways to add flair to your letters.
Flourishing is the older, larger, fancier sibling of flair!

In order of fanciness . . .

a little . . .

A

. . . a lot . . .

A

. . . a ton!

A

Experiment with new ways
to draw a basic letter!

When initially trying to
flourish, keep it simple
until it feels natural.

Adding a flourish to
an ascending letter
is the easiest place
to start.

Make sure that even with flourishing the letter is still recognizable.

Crossbars are a great place to start flourishing both sides of a letter.

Descending letters, especially if they are the last letter in a word, are perfect for long, drawn-out flourishes.

Practice these basic flourishing strokes over and over until they flow naturally.

These strokes can be used to create longer, more complicated flourishes. Once you've practiced them, you can start creating your own loops and whorls.

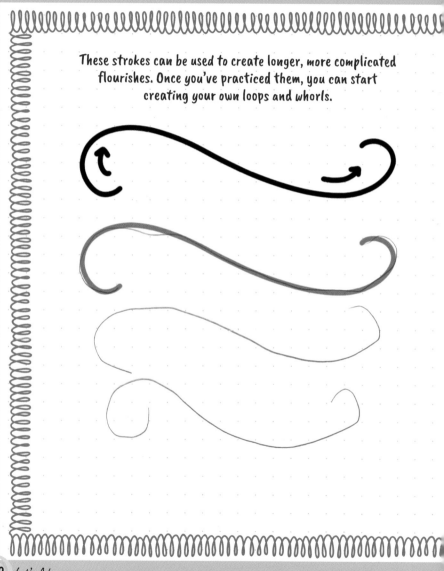

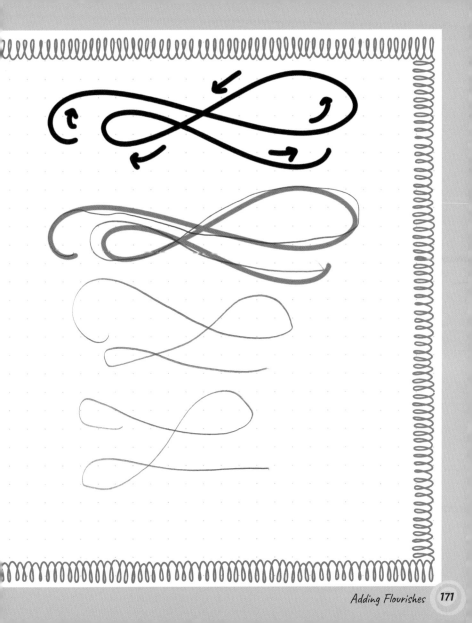

Write your name (or a loved one's name) using the flourishing strokes you've practiced. You can start small, but go big and fancy at least once!

Decorating Letters

Add doodles to your letters to personalize them in an adorable way.

HAVE FUN WITH CUTE DOODLES!

Doodle in front . . .

. . . behind . . .

. . . or around.

1

2

3

When drawing over in pen,
draw the doodle first, then
the parts of the letter showing
around the doodle.

Behind

To decorate behind,
draw the letter first
and then the doodle.

1

2

3

Decorating Letters 175

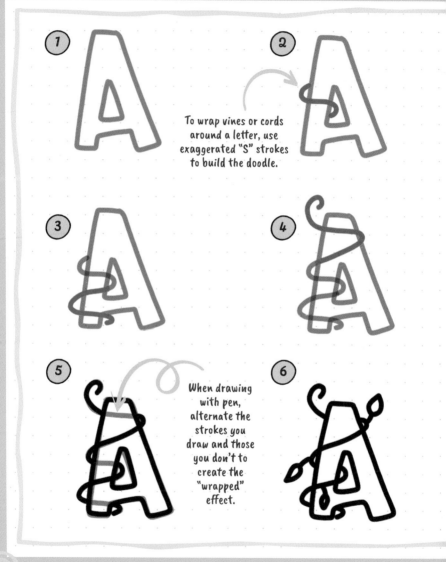

1

2 To wrap vines or cords around a letter, use exaggerated "S" strokes to build the doodle.

3

4

5 When drawing with pen, alternate the strokes you draw and those you don't to create the "wrapped" effect.

6

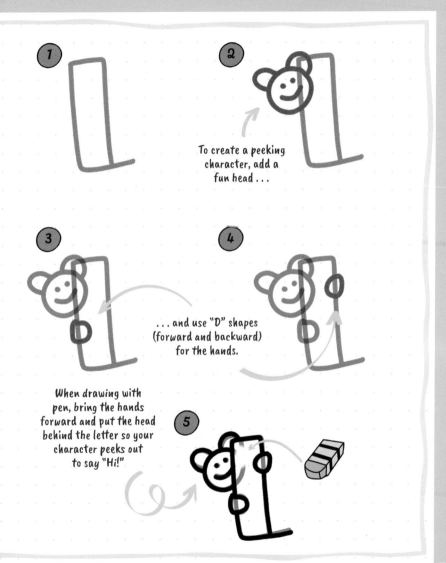

1

2

To create a peeking
character, add a
fun head . . .

3

4

. . . and use "D" shapes
(forward and backward)
for the hands.

When drawing with
pen, bring the hands
forward and put the head
behind the letter so your
character peeks out
to say "Hi!"

5

Use these doodle ideas to inspire your own creations.

Plants

Weather

Bugs

Use these letters to experiment with all sorts of
decorating—in front, behind, wrapped around—
using a mix of different doodles.

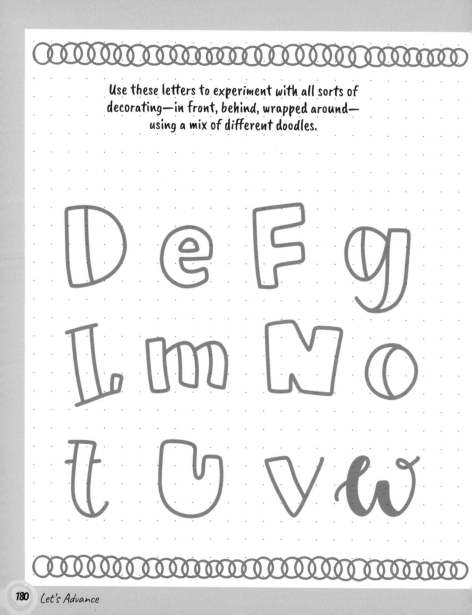

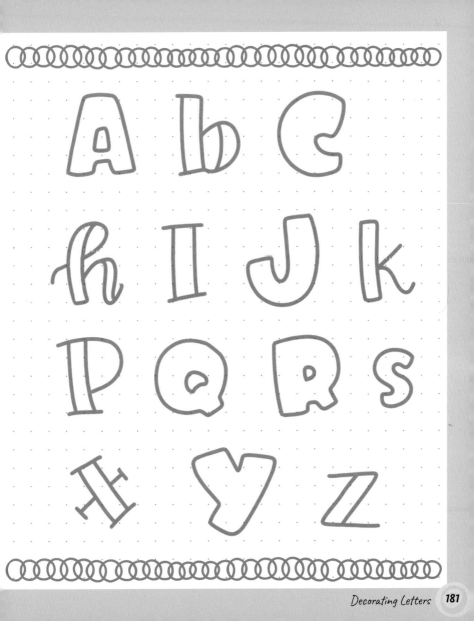

Fill this garden with
decorated letters. How
many can you fit in?

Spacing

The space between individual letters is referred to as kerning.

WHEN IT COMES TO SPACING, CONSISTENCY IS KEY.

1

Measure the space for your word and find the middle.

2

Count the number of letters and divide the space into that number of sections.

3

Add the letters, filling each section but not allowing them to touch the edges. Then erase your guidelines.

The space between words
is called tracking.

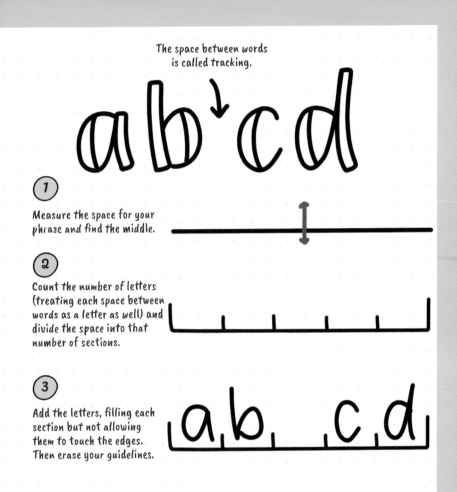

1

Measure the space for your
phrase and find the middle.

2

Count the number of letters
(treating each space between
words as a letter as well) and
divide the space into that
number of sections.

3

Add the letters, filling each
section but not allowing
them to touch the edges.
Then erase your guidelines.

*All letter spaces should be about the same size (with some
adjustments for skinny letters like "I" and wide letters like "W").
All spaces between words should be the same size (although they
can be smaller overall than the letter sections).*

Practice your kerning and tracking. Letter some of your favorite stationery supplies and try different sizes of spacing, both in between letters and in between words.

a b c d e f g

Path to a Great Layout

ABC
def
ghi

1 Choose your lettering styles. Less is more, so stick to around three for most quotes. Pick a bold style, a medium transition style, and a simple style.

2 Choose the words you want to emphasize. Pick words that have the most meaning to you or are the most important to your quote. Those should be in the biggest, boldest lettering style, with your medium words in the transition font and your functional words (like "the," "and," and so on) in the simple style.

SEE PAIRING LETTER STYLES (PAGES 194-195) FOR SOME TIPS ON MIXING LETTERING STYLES.

the WORLD loves MUSIC

3 Experiment with word placement on the page. Give the important words their own area, and keep functional words on their own lines. This will help you begin to visualize the layout.

4

Work out your letter and word spacing (see pages 184–185) and draw in your guidelines. Be sure to leave spacing between each set of guidelines for the size of lettering you want to use there.

5

Sketch your quote in pencil, making any adjustments as you build your piece.

6

Double-check your work for spelling and spacing errors (trust me on this!). When you are satisfied, slowly ink your letters in pen. Let the ink dry completely, then gently erase your guidelines and pencil letters.

NOW FIND A FRAME AND HANG UP YOUR BEAUTIFUL WORK!

Choose a short quote—four to eight
words—and write it in this box.

love yourself
a lot

Use this page to complete Steps 1–3 of the Path to a Great Layout (see page 188).

Use this page to create your quote using Steps 4–6 (see page 189).

REMEMBER TO CHECK YOUR SPELLING BEFORE INKING IN.

CHAPTER 6

Lettering in Journals

Whether you use a pre-printed day planner, create your own bullet journal, or use a diary, hand lettering can help you truly make it your own!

This chapter is full of tips and tricks for using lettering in your planners and journals, no matter what the size or style.

Pairing Letter Styles

There are no hard-and-fast rules for pairing lettering styles, but these tips will help you start making choices and train your eye to know what works well (and what doesn't)! When you're beginning to pair lettering styles, stick to two or three styles at a time. Once you get the hang of things, you can start adding more!

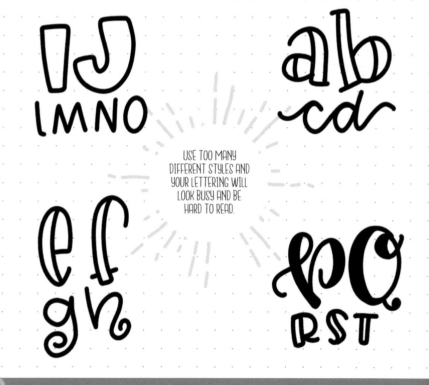

USE TOO MANY DIFFERENT STYLES AND YOUR LETTERING WILL LOOK BUSY AND BE HARD TO READ.

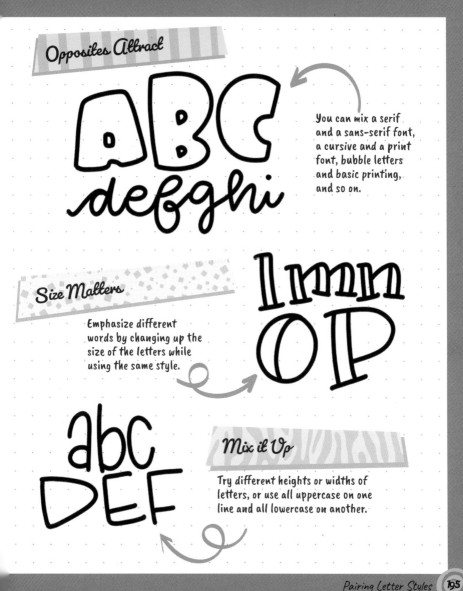

Opposites Attract

ABC defghi

You can mix a serif and a sans-serif font, a cursive and a print font, bubble letters and basic printing, and so on.

Size Matters

Imnn OP

Emphasize different words by changing up the size of the letters while using the same style.

abc DEF

Mix it Up

Try different heights or widths of letters, or use all uppercase on one line and all lowercase on another.

Pick four different pairs of lettering
styles and use them to letter your name
(first and last) four times.

1

Maggie

2

Experiment with pairing lettering styles using the names of famous pairs: Romeo and Juliet, Bonnie and Clyde, Batman and Robin. Pick your pairs and get lettering!

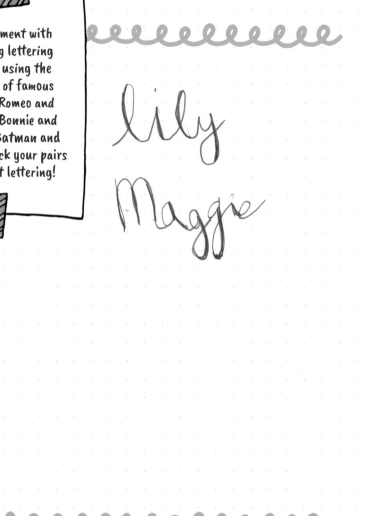

lily

Maggie

Headers

Creating headers in your planner can be as simple as just
using one of the lettering styles from this book, or you can
try some other things!

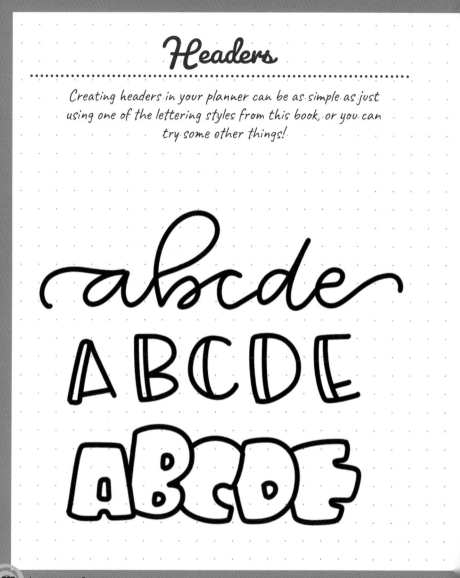

Use a bolder font for the first letter and something simpler for the rest of the word.

Abcd

Efgh

YOU CAN REALLY PLAY AROUND WITH HEADERS.

Decorate

Adding color, fun fill-ins, or decoration to the first letter can really make it pop.

Ijkl

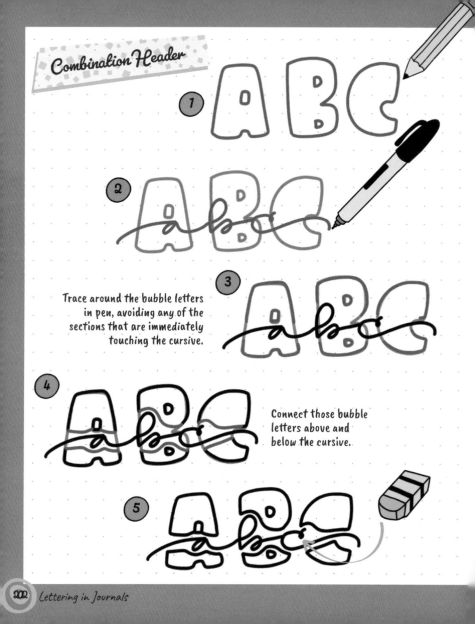

Combination Header

1

2

Trace around the bubble letters in pen, avoiding any of the sections that are immediately touching the cursive.

3

4

Connect those bubble letters above and below the cursive.

5

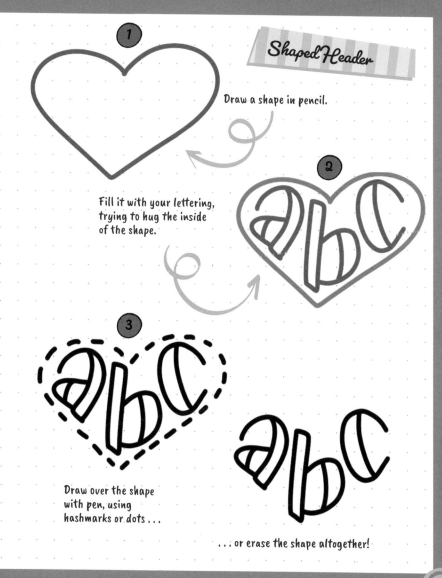

1

Draw a shape in pencil.

Fill it with your lettering, trying to hug the inside of the shape.

2

3

Draw over the shape with pen, using hashmarks or dots . . .

. . . or erase the shape altogether!

Create shaped headers by lettering the names of these shapes into . . . these shapes! Then add borders (or not).

love

star

Practice different types
of headers by lettering
the names of the months.
Don't stick to one style;
try all sorts of different
shapes, sizes, and
pairings!

Banners

Creating headers with lettering is amazing, but to really take your journals and planners to the next level, add a banner!

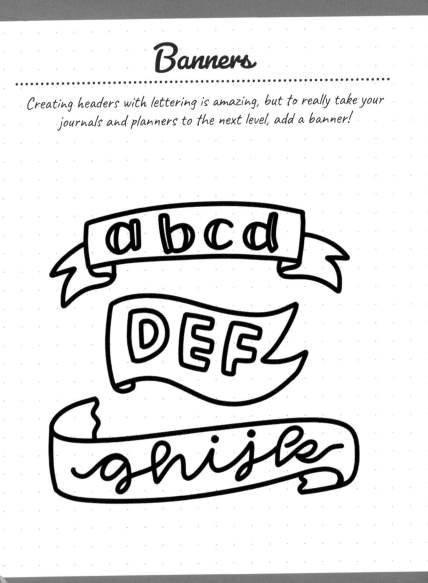

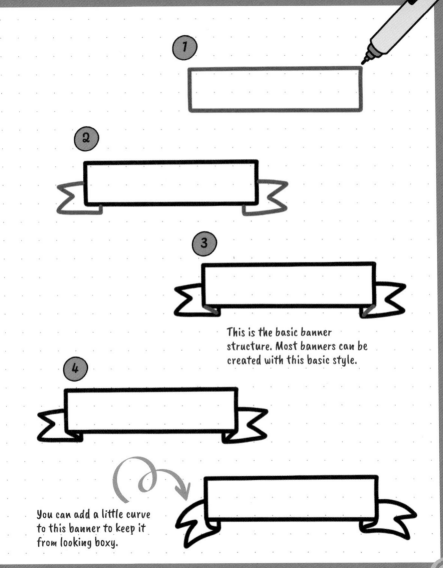

This is the basic banner structure. Most banners can be created with this basic style.

You can add a little curve to this banner to keep it from looking boxy.

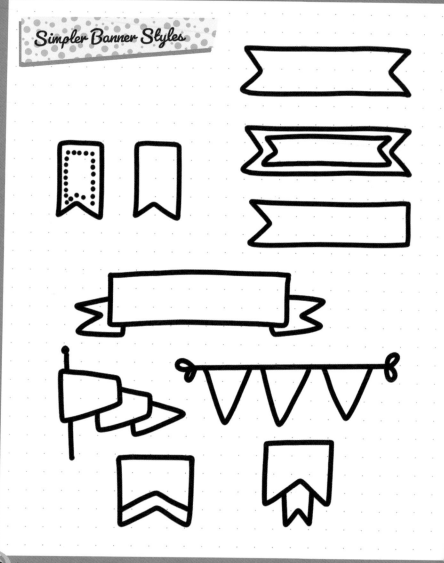

Simpler Banner Styles

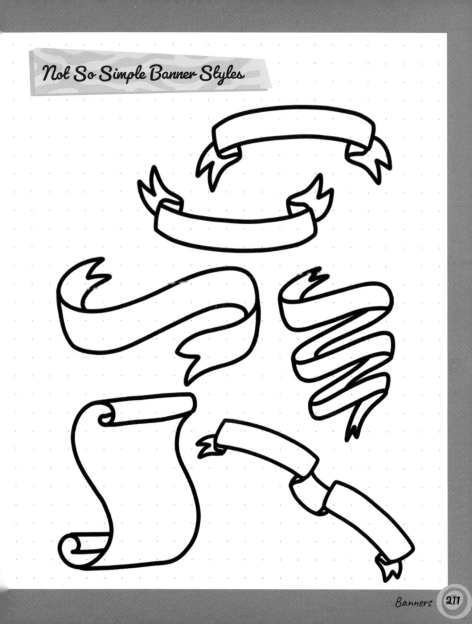

Challenge yourself to draw the banner styles from pages 210–211, or create some of your own!

Filling in the Space

Pre-printed planners have different layouts, which
will determine how you use hand lettering.

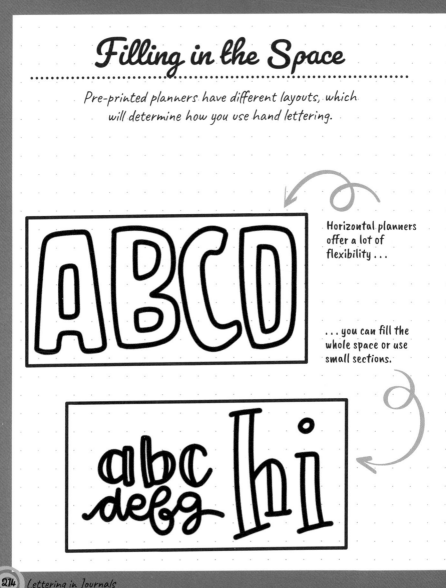

Horizontal planners
offer a lot of
flexibility . . .

. . . you can fill the
whole space or use
small sections.

KLMN

Vertical planners present more of a challenge. Try turning your planner sidewise and lettering across the column.

OP QR

Take a longer word and break it down into sections using the same font . . .

st uv

. . . or mix it up with different lettering styles.

Try out different styles of lettering in these boxes.
Pretend you're using planners with vertical or
horizontal layouts and adapt your lettering to them.

Working Small

If you've learned to letter on a larger scale,
shrinking it down for your journal can be tricky.

From this...

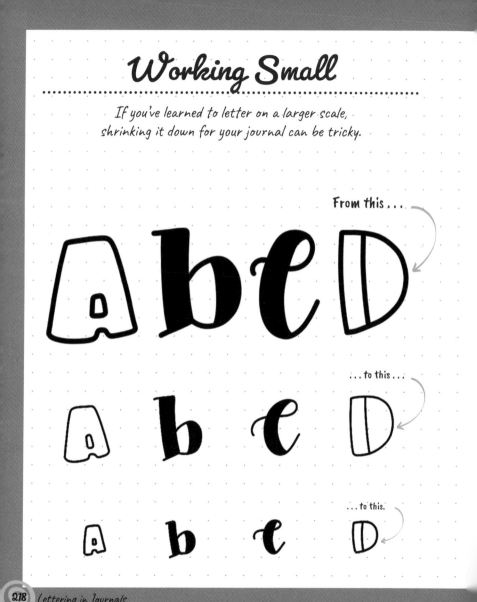

...to this...

...to this.

Try using a finer-tipped pen. I practice with a medium-point marker pen, but for my planners I often use a skinny gel pen.

SMALLER TIP = SMALLER LETTERS!

Practice with simpler letters first—don't try to shrink down bubble or block letters until you're comfortable with some of the thinner, less complicated ones.

This . . .

. . . not that!

Create small spaces (like rectangles) to practice in. This will force you to get better at working smaller because you don't have all the room in the world.

Use this page to test out various pens. Try different tip sizes, different inks or pen styles, and even different colors! Find one or two that you are most comfortable with.

Practice the simple lettering styles, such as bulky and romantic printing, in these boxes. See how small you can make them!

A b C

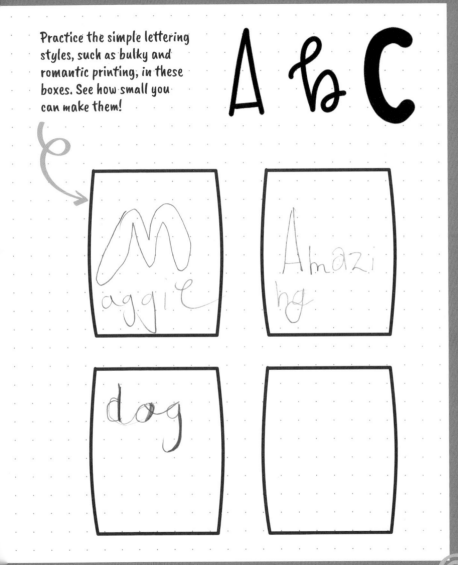

Maggie

Amazing

dog

In these boxes make
smaller versions of the
lettering styles from sans
serif to faux-lligraphy!

AbC

Work on the more advanced styles from Chapter 4 in these boxes. Use a pencil to start if you are worried about making small bubble letters.

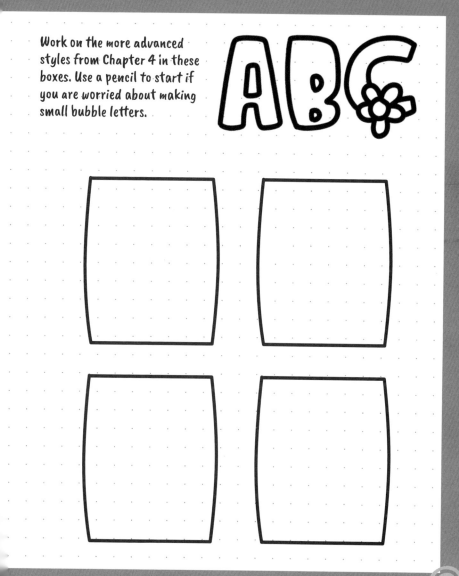

Ideas For Your Journals

Not sure where to start lettering in your planner or journal? Here are some ideas to get you going!

☐ **MONTHLY HEADERS**
Whether on a calendar or your monthly to-do list.

☐ **WEEKLY HEADERS**
The same idea, only for each day of the week, or for your weekly to-do list!

☐ **TO-DO CATEGORIES**
Work, house, kids, self-care, school, pets, and so on.

☐ **TRACKERS**
Finance, habits, workouts, water, and so on.

MEAL PLAN
Try lettering the days of the week on a tracker and laminate it, or letter each meal on your plan for weekly practice!

EVENT PLANNING
Birthday parties, group dinners, vacations, gift lists, and so on.

BUDGETING
Categories for a monthly budget, big money goals, labeling cash envelopes.

INFO PAGES
Health information and appointments, vehicle or home maintenance, important phone numbers, school information.

CHALLENGES
Find a lettering challenge that inspires you or create your own, and practice it every day in your planner.

Use these pages to brainstorm
your own ideas for your planners
and journals. For bonus points,
letter your ideas!

- []
- []
- []
- []
- []
- []

Lettering Cheat Sheet

Here are some tips and tricks for quick reference while you continue on your lettering journey.

Remember that the most important thing you can do to improve your lettering is continue practicing as often as you can.

SMALL CHANGES =
BIG
IMPACT!

When learning and practicing, remember that slow, steady, consistent practice will be the most helpful.

Trying different pens (and other writing instruments) can change up your lettering.

Try gel pens . . .

ABC

ABC

. . . markers . . .

. . . brush pens . . .

abc

abc

. . . even chalk or crayons!

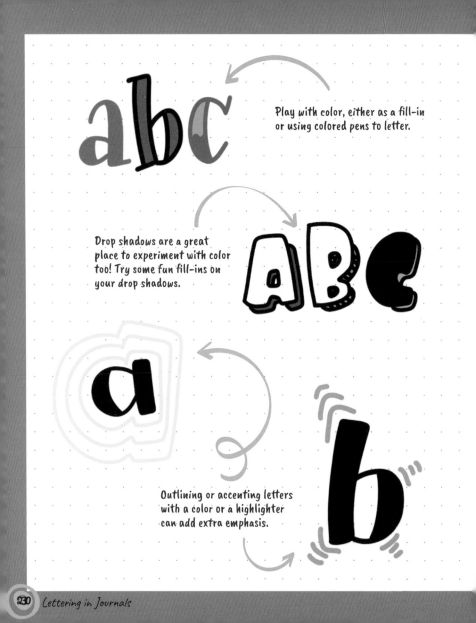

Play with color, either as a fill-in or using colored pens to letter.

Drop shadows are a great place to experiment with color too! Try some fun fill-ins on your drop shadows.

Outlining or accenting letters with a color or a highlighter can add extra emphasis.

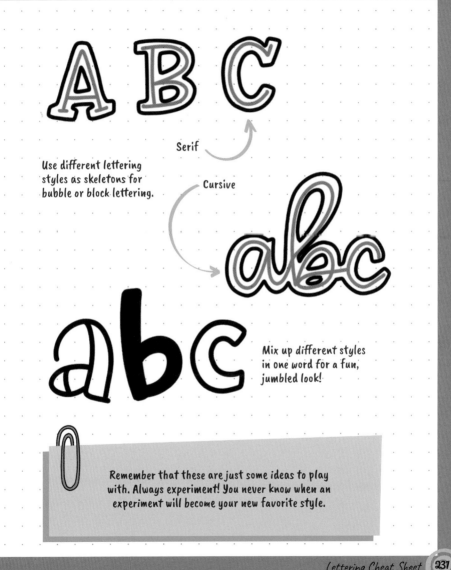

Serif

Use different lettering styles as skeletons for bubble or block lettering.

Cursive

Mix up different styles in one word for a fun, jumbled look!

Remember that these are just some ideas to play with. Always experiment! You never know when an experiment will become your new favorite style.

CHAPTER 7

What Do I Do Next?

Congratulations! You've made it through the book.
You've picked up some new lettering skills and
hopefully you've built some confidence along the way.

But what next? How do you continue your lettering
journey? I'll be giving you some advice and prompts
in this chapter to move you into the future!

Moving Forward

There are three big tasks ahead of you,
now that you've completed this book.

USE WHAT YOU'VE LEARNED

In Chapter 6 I gave you a list, and you also made your own, of ways to use your lettering in your planners and journals (see pages 224–227). So, use it, and not just there. Letter your meal plan for the week on a chalkboard. Letter a sign for a yard sale. Put these new skills to good use!

SHARE WHAT YOU'VE LEARNED

Take pictures of your practicing and of your finished pieces, and share them with people you know (and people you don't). Post them on social media. You never know, you might be asked to hand letter something for a friend and maybe even get paid for it.

KEEP PRACTICING AND LEARNING

This book is the beginning, not the end, of a journey. Seek out communities and resources to help you continue to get better and learn new things. You can start by looking me up online!

What Do I Do Next?

Need some more ideas for practicing?
Here are some prompts in case you draw a blank.

Pick a season and letter your favorite things about it.

What is your first childhood memory?

List every street you've ever lived on.

List your favorite artists, musicians, or poets.

Choose a favorite song and letter the lyrics.

Where is your dream vacation? What would you do there?

If you could only eat ten things for the rest of your life, what would they be?

Letter the names of the TV shows you loved as a kid.

List all the books you want to read.

Which chores do you hate doing?

What are the longest words you know?

Letter your favorite beverages, adult or otherwise!

Who are your favorite people in the world?

What movies would you like to see this year?

List all the cities you've ever visited.

And don't forget, you can return to any of the previous practice pages and use those prompts as well.

Take Your Handwriting Temperature

While you've spent the majority of this book on hand lettering, working on your lettering also helps improve your handwriting. Use these pages to look back on and celebrate the progress you've made throughout the book!

What improvements have you noticed in your handwriting?

What changes would you like to work on next? Be specific.

Write the entire alphabet, in uppercase and lowercase, in your regular writing. Remember to write slowly, and have a tasty beverage when you're done. I'm proud of you!

A B C D E F G H I J K
L M N O P Q R S T U V W X Y Z
a b c d e f g h i j k l m n o p q r s t
u v w x y z

Date ...

Index

A
ascender 23, 98

B
banners, creating 208–211
block lettering 110–117, 158–159, 219, 231
bouncy cursive 152–155
bouncy printing 146–147
bubble lettering 122–131, 138–143, 158–159
bulky letter style 58–60, 102, 104

C
capital letters *see* uppercase letters
cheat sheet 228–231
color, use of 19
connecting letters 44–47
crossbar 23, 99
cursive letters, building 38–39
cursive strokes 22, 36–37

D
decorating letters 174–179
descender 23, 99
downstroke 23, 82–87

E
erasers 20

F
faux-lligraphy 82–87
fill-in techniques 90–95
flourishing, add 164–171

G
grip, pen 19

H
handwriting 14, 24–25, 236–237
headers, creating 200–203
highlights, fill-in 93

I
ideas, project 234–235
ideas, journal 224–225

J
journal ideas 224–225
journals, lettering in 194–195

L
layouts 188–189
lettering, what is 14–15

lettering jargon 22–23
lightboxes/light tables 21
lowercase letters 22

m
materials, tools and 18–19, 20–21

n
numbers and symbols 102–105,
 158–159

p
paper, practice 20
pencils 20
pens 18–19, 21
practice, daily 16–17
practice pages 26–27
print 22
printing, basic 30–31

R
romantic printing 64–67, 102, 104
ruler 20

S
sans serif 22, 70–73, 103, 105
serif 22, 103, 105
serifs, adding 76–79
shapes, fill-in 92
size, scaling down 218–219
skeleton 23
solids, fill-in 91
space, filling the 214–215
spacing letters (kerning) 184–185
stripes, fill-in 90
stroke 23
style, changing 50–51

T
tail 23
tools and materials 18–19, 20–21
tracking 185

U
uppercase letters 22, 47, 97
upstroke 23

Acknowledgments

I want to thank my husband, Jesse Baldo, for believing in me, even when I didn't believe in myself, and my kids, Kat and RJ, for at least once in my life acknowledging I'm "cool," the ultimate compliment from teenagers.

My family, especially my sisters, Amy and Becca, and my uncle Rich, have put up with my shenanigans and kept my secrets, and my dear friend Kristin Damian has been a constant source of support and inspiration.

Thanks to Kate Kirby, Claire Waite Brown, and all the folks at Quarto Publishing for bringing this book to life in spectacular fashion, and to Jeanette Richardson, the team at Wild For Planners, and the entire Planners Gone Wild community for putting my feet on the path that got me here, and cheering me on along the way.

Thanks also to the whole CGB community over on YouTube and Facebook for being smart, compassionate, creative, funny, irreverent, kind, honest, all of those things that I hope to be most days, and you demonstrate every day in the comments, to each other and to me.

And finally, to my Patreon supporters. I'd name you all here if I could, but for those who supported for one month, those who have continuously supported from the beginning, and all of you in between, thank you. Thank you, thank you, thank you. None of this would be possible without you. You have changed my life and the lives of my family, and I am honored to spend my time with you.